Emily Carr

AN

INTRODUCTION

TO HER

LIFE AND ART

FIREFLY BOOKS

BOOKMAKERS PRESS

Anne Newlands

Cataloguing-in-Publication Data

Newlands, Anne, 1952-
 Emily Carr : an introduction to her life & art

Includes bibliographical references.
ISBN 1-55209-046-9 (bound)
ISBN 1-55209-045-0 (pbk.)

1. Carr, Emily, 1871-1945.
2. Painters – Canada – Biography.
I. Carr, Emily, 1871-1945. II. Title.

ND249.C3N48 1996 759.11 C96-930949-X

A FIREFLY BOOK

Published by
Firefly Books Ltd.
3680 Victoria Park Avenue
Willowdale, Ontario
Canada M2H 3K1

Published in the U.S. by
Firefly Books (U.S.) Inc.
P.O. Box 1338, Ellicott Station
Buffalo, New York 14205

Produced by
Bookmakers Press Inc.
12 Pine Street
Kingston, Ontario K7K 1W1

Design by
Linda J. Menyes
Q Kumquat Designs

Color separations by
Friesens
Altona, Manitoba

Printed and bound in Canada by
Friesens
Altona, Manitoba

Printed on acid-free paper

Front Cover: Emily Carr, *Among the Firs*,
c. 1930-40; oil on canvas, 91.5 x 76.2 cm.
Glenbow Collection. Courtesy Glenbow Museum
and Art Gallery, Calgary, Alberta.

Back Cover: Emily Carr, *Arbutus Tree*, 1922;
oil on canvas, 46.0 x 36.0 cm; National Gallery
of Canada, Ottawa. Thomas Gardiner Keir
Bequest, 1990.

For my parents, who
encouraged my first interest
in art, and with many
thanks to Andrew, Martha
and Howard.

Contents

Self-Portrait

Far from the mounting tensions in Europe that by 1939 would erupt into the Second World War, Emily Carr, 67 years old, sat in her quiet Victoria studio and created this self-portrait. Working freely and spontaneously, she made no pretence about her appearance, presenting herself in her customary attire—a net cap over her hair and a loose-fitting dress, so suited to her profession as a painter.

In its simplicity and directness, the self-portrait is both a view of Carr's exterior self and an expression of her inner beliefs. As the bold brush strokes capture her generous bulk and focused look, they also embody her personal values and those she admired in others: honesty, sincerity and strength.

By the time she painted this work, Carr had at last been recognized as one of Canada's most important artists. But it had sometimes been an arduous struggle for a woman born in 1871 in the staid provincial capital of British Columbia, where the role of most women was limited either to raising children or to teaching them. Women did not even have the right to vote until 1917, when Carr herself was middle-aged.

At the turn of the century, Victoria was still relatively young compared with the older established cities of eastern Canada. In Carr's words: "Victoria stood like a gawky girl, waiting, waiting to be a grown-up city." A frontier town with a thin veneer of British culture that managed to smooth over the ruggedness of the natural environment, the city was also home to large numbers of First Nations people and Chinese labourers. "By and by," wrote Carr, "the English forgave the West her uncouth vastness and the West forgave them their narrow littleness."

Only a few years before painting this self-portrait, Carr had described herself as a "little old lady on the edge of nowhere," a rather truthful summing up of the geographical, artistic and emotional isolation in which she had developed as an artist. While Victoria itself was removed from the more vibrant mainland city of Vancouver by a six-hour ferry ride, the entire province was separated from the rest of Canada by the majestic barrier of the Rocky Mountains.

Some of Carr's isolation was a matter of choice. There were, in fact, many other artists in Victoria during the years that she lived there, but generally, she chose not to associate with them. Carr was not interested in the local art clubs that embraced knitting and needlework as well as painting and sculpture. She preferred to follow a path of her own, displaying courage and perseverance in her determination to realize her vision both as an artist and as a writer.

The art of Emily Carr is a portrait of the artist's lifelong search for meaning and expression, from her beginnings as a traditional artist through her explorations of new styles and influences and her discovery of a highly personal manner of visual and verbal expression. In this self-portrait, Carr looks at us candidly, inviting us to explore her work and embark upon our own journey of discovery.

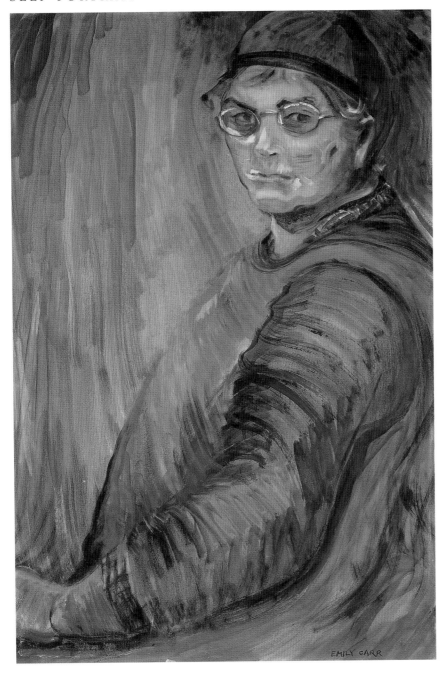

Emily Carr, *Self-Portrait*,
1938-39; oil on wove paper,
mounted on plywood,
85.5 x 57.7 cm;
National Gallery of Canada,
Ottawa. Gift of
Peter Bronfman, 1990.

Beginnings

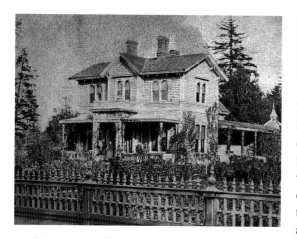

Looking at these formal portraits of Emily Carr's well-dressed parents—Richard and Emily—it is not hard to imagine the atmosphere of respectability and comfort that would have existed in the large, attractive house which still stands on Government Street in Victoria, British Columbia.

Richard Carr had come a long way from his humble birth in England, where he had received only an elementary school education. From his diary, we learn of his wanderings across the Americas, from Peru to Quebec. To support himself, Carr hired on as a deck hand, a harvester and an ice fisherman; in Mexico, he worked as a photographer, travelling by horseback. Lured to California by the gold rush in 1848, Carr had done well enough after two years in the mines to open a dry-goods store. Within another two years, he and a partner had opened three more stores.

Emily Carr was named for her mother, Emily Saunders, who met Carr's father in a San Francisco boardinghouse. We know very little of

Emily Saunders' past, except that she was 18 years old when she and Richard were married in 1854. After the birth of two daughters, Richard Carr returned with his family to England.

Their stay in Carr's homeland was not particularly happy. The smoky industrial air damaged Mrs. Carr's weak lungs, and the family was saddened by the death of two infant sons. Apart from these misfortunes, England seemed somewhat dull after the excitement and adventure of the New World. The Carrs decided to return to North America in 1863, choosing Victoria as their new home. Later, Emily Carr would describe the proper little town on the southern tip of Vancouver Island as "the most English-tasting bit of all Canada."

Founded in 1843 as the West Coast headquarters of the Hudson's Bay Company, Victoria had been named for the reigning British monarch. In 1858, the Fraser River gold rush brought thousands of people through the town, creating an economic boom and rapid expansion. When Richard Carr arrived five years later, it was still an ideal time to establish a dry-goods business and to build a home on 10 acres at the edge of town for his growing family.

"The house was large and well-built, of California redwood, the garden prim and carefully tended," Carr wrote in *The Book of Small*. "Everything about it was extremely English." It was in this house that the artist and writer would be born on December 13, 1871. Many years later, on the eve of her fifty-sixth birthday, Carr described the day of her birth in her journals: "My dear little Mother wrestled bravely and I was born and the storm has never quite lulled in my life. I've always been tossing and wrestling and buffeting it."

The Carr House, Victoria, British Columbia, c. 1874. Photograph courtesy British Columbia Archives and Records Service; Catalogue #49835.

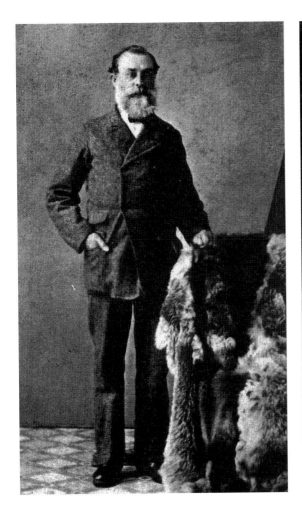

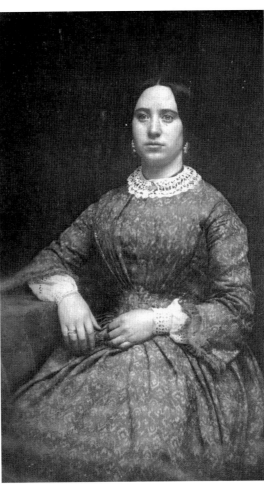

Richard Carr,
Emily's father, 1876.
Photograph courtesy
British Columbia Archives
and Records Service;
Catalogue #93620.

Emily Saunders Carr,
Emily's mother,
two months after her
marriage to Richard, 1855.
Photograph courtesy
British Columbia Archives
and Records Service;
Catalogue #93618.

Carr's Youth

The most endearing and engaging accounts of Emily Carr's youth are those created by Carr herself. *Growing Pains*, an autobiography, and *The Book of Small*, a collection of stories about her childhood, were both written when Carr was in her sixties, as the artist looked back on her life through the sometimes hazy filter of time. While neither book is always factually reliable, each provides us with records of remembered feelings and with valuable insights into Carr's inner spirit and personality.

The seeds of the powerful individual that Carr would become were sown in her youth. In *Growing Pains*, she admitted she was "contrary from the start.... I was the disturbing element of the family. The others were prim, orthodox, religious." From her reported struggle at age 4 with the minister at her baptism, in which she described herself as being presented "kicking furiously to God," to her delight at embarrassing her bossy older sisters by playing in the mud in her Sunday best, Carr celebrates her independence and difference. She would require that same independence to pursue her career as an artist, isolated from the established centres of art.

The staid family photographs give no hint of Carr's early rebelliousness. In the picture taken a year after her baptism, she seems a bit forlorn. And in the picture taken two years after her mother's death, the teenage Carr sits demurely with her siblings, prettily arrayed in a lace collar, slightly brooding and serious.

When she was about 8 years old, Carr drew a picture of her father's dog that so impressed him, he arranged for her to take drawing lessons. In the Victoria of Carr's day, an interest in art was considered a ladylike pastime, somewhat akin to embroidery. It was certainly not a serious occu-

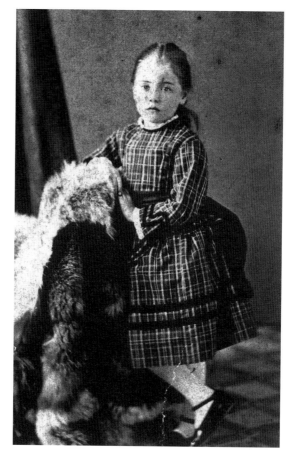

Emily Carr, age 5. Photograph courtesy British Columbia Archives and Records Service; Catalogue #99263.

pation for women. Carr's father probably never dreamed he was launching the career of one of Canada's great artists.

Carr's love of nature—from her great affection for animals to her enjoyment of the forest—began in her childhood. In *Growing Pains*, she wrote of the joy of escaping the Carr household's rules and rigidity by galloping into the countryside on an old circus pony named Johnny, which took her to "the deep, lovely places that were the very foundation on which my work as a painter was to be built."

The five Carr sisters, clockwise from lower right: Emily, Alice, Lizzie, Edith and Clara, c. 1888. Photograph courtesy British Columbia Archives and Records Service; Catalogue #5131.

San Francisco

MODEL STUDY

Emily Carr's hometown had very little to offer aspiring artists. In Carr's own words, "Victoria was like a lying down cow, chewing." There were no art schools, art collections or professional artists from whom a young artist could learn. For Carr, the obvious solution was to study in Europe or the United States.

When Richard Carr died in 1888—two years after the death of his wife—he left a trust fund to provide for the needs of his five children. The eldest, Edith, was appointed head of the household, and she would not hear of her youngest sister travelling to England or France to study art. Determined, Carr approached the family's trustee and persuaded him to provide her with money to study in San Francisco, which would be less costly and closer to home.

The California School of Design was a respected if somewhat dilapidated institution staffed with artists who had been trained in Europe. Although the school's approach was conservative, it was a good place for Carr to learn the rudiments of drawing and painting. The standard curriculum included drawing from plaster replicas of classical sculpture as well as exploring the human figure, portraiture, still life and landscape. A shy person, Carr avoided what was known as the "life class," where students worked with a nude model.

By Carr's own admission, the work that she brought home after three years of study in San Francisco was "humdrum and unemotional—objects honestly portrayed, nothing more." Typical of a studio still life, *Melons* is an example of Carr's early exploration of composition. In it, she attempts to establish a sense of space and volume through the use of colour and the contrast of light and shadow. In the study of a little girl, *Model Study*, she displays her powers of observation, depicting the timidity of the child, who sits patiently on a fur rug posing for the students. Studio work provided Carr with a good foundation, but she much preferred the outdoor sketching classes she mentioned in *Growing Pains*, where "things asked to be felt not with fingertips but with one's whole self."

In San Francisco, free of family pressure, Carr was able to participate in the routine of a real art school and an artistic community impossible to find in Victoria. In late 1893, however, when the Carr family finances could no longer support her studies away, that experience came to an end.

Emily Carr, *Model Study*, c. 1890-93; graphite and white gouache on wove paper, mounted on masonite, 35.6 x 25.5 cm; National Gallery of Canada, Ottawa.

Emily Carr, *Melons*, 1892;
oil on canvas. Courtesy
Newcombe Collection,
British Columbia Archives
and Records Service;
Catalogue #PDP 650.

Klee Wyck

Back in Victoria, Emily Carr discovered that her sisters had transformed the family's house into a Sunday school and a meeting place for the newly founded YWCA. Feeling overwhelmed by "the great furious helps" of organized religion and keen to establish herself as an artist, Carr began teaching art to the neighbourhood children to earn money for her studies in Europe.

At first, the lessons were held in the family dining room, but when her sisters objected to the noise and disorder, she created a studio in the loft of the cow barn that she recalled in *Growing Pains*: "No studio has ever been so dear to me as that old loft smelling of hay and apples, new sawed wood, Monday washings, earthy garden tools."

In the spring of 1899, Carr was invited by a missionary friend of her sister Lizzie to travel to Ucluelet, a Nuu-Chah-Nulth (Nootka) reserve on the west coast of Vancouver Island. "To attempt to paint the Western forests did not occur to me," she wrote in *Growing Pains*. "I nibbled at silhouetted edges. I drew boats and houses, things made out of tangible stuff." Examples of her work from this period confirm her statement. In this pen-and-ink sketch, neatly drawn houses cluster by a nearly deserted shore, and the forest, which would later become a major subject, is hastily filled in with zigzag lines.

It was on this trip that Carr earned the native name "Klee Wyck," which means "Laughing One." Never interested in learning other languages, Carr managed to communicate with the Nuu-Chah-Nulth by nodding, gesturing and smiling. Regarding herself as someone who lived outside conventional society, she felt a bond with these people, whose culture was so distinct from that of the immigrant population. As she sketched, the villagers viewed her with curiosity; in *Cedar Canim's House, Ucluelet*, children watch as she quickly paints them from her view at the bottom of the hill. Many years later, she published the stories of her encounters with the First Nations people under the title *Klee Wyck*.

On the return trip to Victoria, the ship's purser, William Locke Paddon, fell in love with Carr—"an immense love that I could neither accept [nor] return." By the end of the summer, she had saved enough money to study abroad, and she decided to go to London, England, hoping to rid herself of the persistent Paddon in the process. When he followed her there, Carr flatly refused to marry him. Her art came first, and she was not interested in sacrificing it to the compromises that domestic responsibilities and children would demand. It was a decision she would stand by for the rest of her life.

Emily Carr, *Indian Village, Ucluelet*, 1899; pen and ink. Courtesy Newcombe Collection, British Columbia Archives and Records Service; Catalogue #PDP 641.

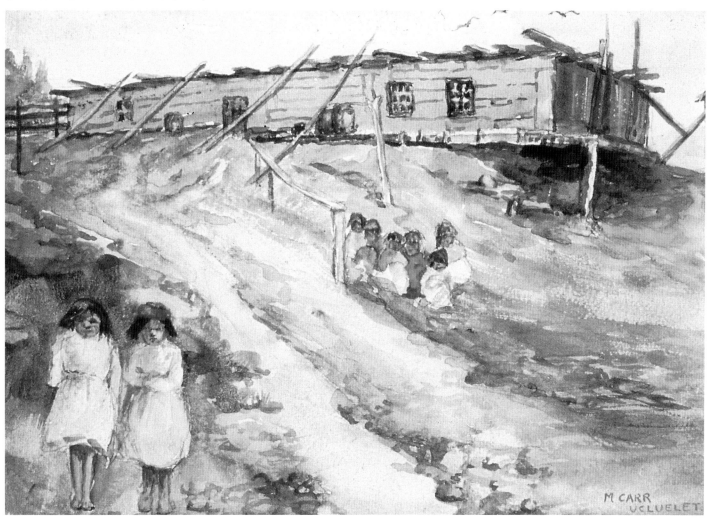

Emily Carr, *Cedar Canim's House, Ucluelet*, 1899; watercolour. Courtesy British Columbia Archives and Records Service; Catalogue #PDP 2158.

England–A Pause

England had several things to recommend it: two of Emily Carr's friends from Victoria had already studied there, the Carr family's British roots would help make the unfamiliar more familiar, and Carr spoke the language. It was a long journey—by boat from Victoria to Vancouver, by train to eastern Canada and, finally, by ship to England, where she endured "the sea-bounce that grieved the stomach and wearied the eye."

Once there, the only thing Carr liked about London was Kew Gardens—a large and famous botanical garden that boasted pines and cedars from British Columbia. London itself, on the other hand, was "unbearable...too many people, too little air." Her experiences at the Westminster School of Art were likewise disap-

pointing and did little to advance the artistic training she had begun in San Francisco as a young woman.

Life was different, however, in the countryside, and Carr's first summer was happily spent with an outdoor sketching class in Berkshire. Leaving London for good, she then travelled to St. Ives, an artistic colony by the sea in southwestern England. For a year, she studied with a seascape painter but found the "glare and racket" of the ocean unappealing. To her relief, another teacher encouraged her to work in the "haunting, ivy-draped, solemn" woods nearby—a subject to which she was already attached.

Despite Carr's sturdy appearance, her health was unstable. In the fall of 1902, she collapsed with acute anaemia and had to be placed in the East Anglia Sanatorium, where she was confined for 18 months, an experience recounted in a book of Carr's stories called *Pause*. While there, "surrounded by slow-dyings and coughing," she became fascinated by a species of songbird she had never seen in British Columbia and persuaded her doctors to let her raise some by hand. The newly hatched chicks spent their first days in her room, and in this sketch, Carr pictures herself in bed, sleepy-eyed and grouchy. "Darn 'Em," she scribbles, obviously not enjoying the early-morning feeding.

The English sojourn was truly a "pause" in Carr's artistic career. The landscape painting, most of which she later destroyed, had at least been a pleasure, but the year and a half in the sanatorium had been a real setback. Her recovery and return to Victoria raised her spirits. As she wrote in *Growing Pains*, "Sad I was about my failures, but deep down my heart sang: I was returning to Canada."

Emily Carr in England, 1901-02. Photograph courtesy British Columbia Archives and Records Service; Catalogue #27429.

5 O'CLOCK AM, AP. 15, 1903, DARN 'EM

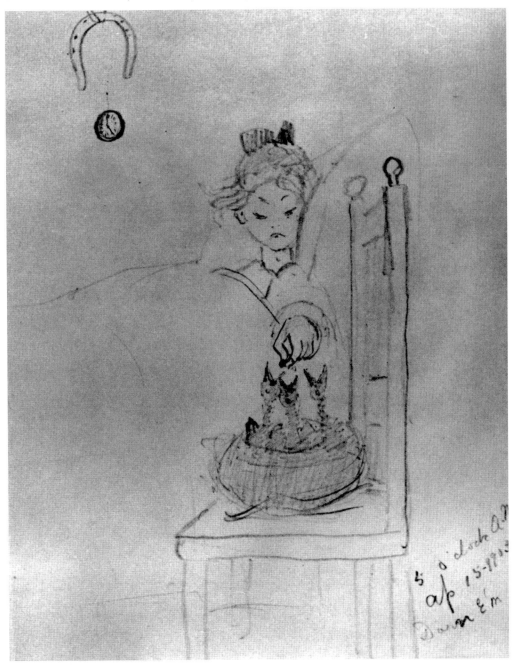

Emily Carr, *5 o'clock am, Ap. 15, 1903, Darn 'Em*, black-and-white sketch. From *Pause*, Emily Carr; Clarke Irwin and Company Ltd., 1953. Courtesy Stoddart Publishing Co. Ltd.

Stanley Park

On her trip back to Victoria, Emily Carr made a six-week stopover to visit friends who lived in the cattle-raising Cariboo area of central British Columbia. "Mounted on a cow pony I roamed the land…how happy I was!" Carr later recounted. "Though far from strong yet, in this freedom and fine air I was gaining every week."

Invigorated by her stay in the country, Carr arrived home to some attention from the Victoria press. An article entitled "Miss Carr Returns From Five-Year Study Under English Masters" perhaps exaggerated her accomplishments. Nevertheless, she got a part-time job as a political cartoonist in a Victoria publication called *The Week*.

While the topics were probably selected by the newspaper's editors, the interpretations were very much Carr's, and drawings such as *At Beacon Hill, May 24*, which portrays the inevitable modernization of Victoria, reveal her lively sense of humour and imagination. As far as art was concerned, however, Victoria remained locked in the conservative 19th century. It was with some relief that Carr accepted an invitation to teach at the Vancouver Studio Club.

Although she was enthusiastic about the move to Vancouver, the job of teaching the "society ladies" at the Studio Club was both unsuccessful and short-lived. Carr was too serious for the matrons, and they were not serious enough for her. She continued to paint and soon attracted younger students, who appreciated her insistence on working directly from nature, both in the studio as well as in nearby Stanley Park, with

its "gigantic spreads of pines and cedar boughs." In the heart of Vancouver, Carr was instinctively drawn to the comforting shelter of the forest, soothed and protected by "the cool sap of vegetation"—just as she had sought refuge in the greenness of Kew Gardens in London.

Her technique in *Wood Interior*, where soft greens and warm browns are delicately applied, reflects the conservative teaching she had received in England. The composition, however, where light and air waft between the towering trees and the gently moving foliage, is one that she would explore later in her life.

On this work, as well as on many others, Carr's signature appears as "M. Emily Carr." The "M" stands for Millie, her family nickname, an initial she often used to distinguish herself from her sisters Elizabeth and Edith.

Emily Carr, *At Beacon Hill, May 24*, from *The Week*, May 27, 1905. Courtesy British Columbia Archives and Records Service; Catalogue #42672.

WOOD INTERIOR

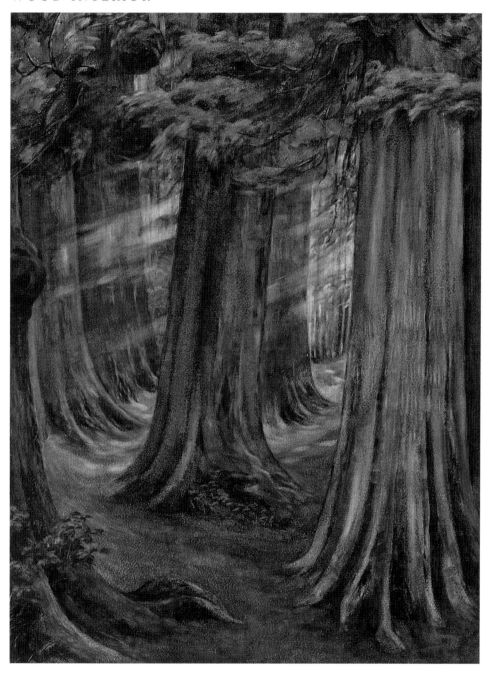

Emily Carr, *Wood Interior*, 1909; VAG 42.3.86; watercolour on paper, 72.5 x 54.3 cm; Emily Carr Trust. Courtesy Vancouver Art Gallery. Photograph by Trevor Mills.

A Commitment to First Nations Art

ALERT BAY

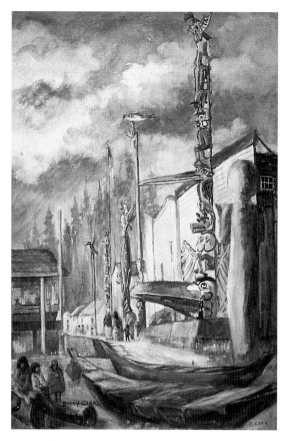

Most of Emily Carr's Vancouver years were spent teaching, and during that time, her knowledge and understanding of First Nations peoples and their art developed. In the summer of 1907, Carr and her sister Alice took a cruise to Alaska. After several short stops along the way, they spent a week in Sitka, an American naval base on Baranof Island where Carr discovered the so-called Totem Walk. In her painting *Totem Walk at Sitka*, we enter a light-filled path, flanked on either side by tall trees and totem poles that had been gathered from various sites. Here, the leaves and branches of the trees meet overhead, creating a natural tunnel that contrasts with the brightly coloured carvings.

More important for Carr was her discovery of an old Tlingit village on the edge of town, where the carvings still existed in their original settings. She immediately began to make sketches, earning the compliments of an American artist. In *Growing Pains*, Carr described the impact of his response: "The American's praise astounded me, set me thinking.... The Indian people and their art touched me deeply.... By the time I reached home my mind was made up. I was going to picture totem poles in their own village settings as complete a collection of them as I could."

Carr now had a new purpose for her art. Over the course of the next two summers, she embarked on what would become a series of regular sketching trips to distant First Nations villages. Travel was difficult and accommodation uncertain, but she somehow managed, finding shelter in "tents, roadmakers' toolsheds, in missions, and in Indian houses."

In the watercolour *Alert Bay*, Carr focuses on the impressive carvings and totem poles that stood at the entrances of the houses in a village off the northern tip of Vancouver Island. Although she claimed that because of their great height and complex imagery, totem poles were not easy to draw, she succeeds in communicating their character and scale within the village.

But Carr soon became dissatisfied with the gentle style of watercolour painting which she had studied in England, finding that it did not really capture the "bigness and stark reality" of the sculptures themselves. When she heard reports about "the new art" that "claimed bigger, broader seeing," she set her sights on Paris to learn more about it.

Emily Carr, *Alert Bay*, c. 1908-09; watercolour. Courtesy collection of Dr. Michael Gardner.

TOTEM WALK AT SITKA

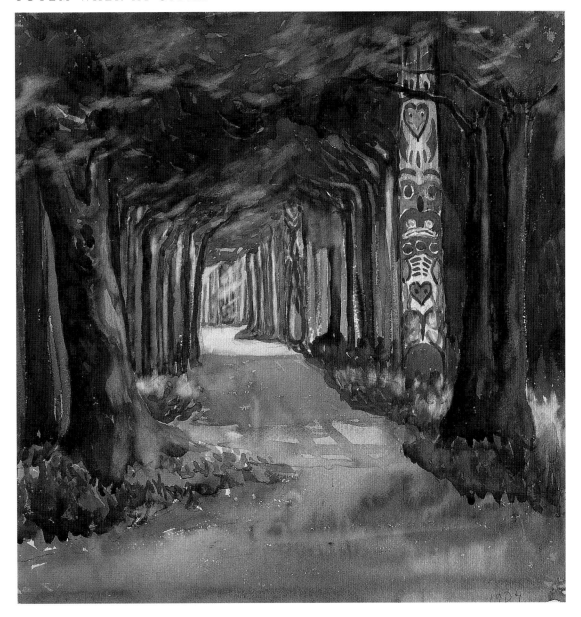

Emily Carr, *Totem Walk at Sitka*, 1907; watercolour on paper. The Thomas Gardiner Keir Bequest. Collection of the Art Gallery of Greater Victoria.

France: The New Art

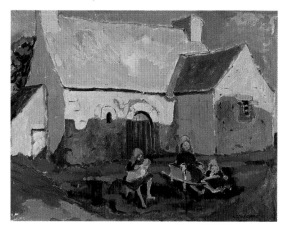

In July of 1910, Emily Carr sailed for France from Quebec City, taking along her sister Alice to act as companion and interpreter. "My sister knew French but would not talk," Carr recalled. "I did not know French and would not learn. ...I wanted *now* to find out what this 'New Art' was about."

Her contact in Paris was a "modern" English artist, Henry Phelan Gibb, whose colourful landscapes excited her and whose distorted nudes shocked her. Gibb recommended that she enrol at the Academie Colorassi, but Carr could not understand the instruction and, after only a few weeks, felt sick in the "miserable, chalky lifelessness" of the studio classes. Gibb then suggested that she study with a Scottish artist who used bright colours and simplified forms, in the style of the Fauves—French artists who were named the "wild beasts" by an art critic for their daring use of colour. This was a stimulating experience for Carr, but the stifling city air in Paris had made her ill. In late winter, she travelled to Sweden to recover.

Returning to France in the spring, Carr followed Gibb first to a small town on the outskirts of Paris and later to Brittany, where she revelled in the beauty of the rural setting. "I tramped the country-side, sketch sack on shoulder," she wrote in *Growing Pains*. "The fields were lovely, lying like a spread of gay patch-work against red-gold wheat, cool, pale oats, red-purple of new-turned soil."

Each day, she sketched and painted on her own; every few days, she met with Gibb to hear his critique of her work. In an unpublished manuscript, Carr recorded her discoveries of the New Art. A painting, she wrote, must be more than "a copy of the woods and fields": it must be about space, colour and light. The painting itself "was more than what was before us"—it had a life of its own independent of the objects or places it represented. Therefore, colours did not have to "match" those of nature; instead, they should express the artist's feelings about the subject.

In *Autumn in France*, Carr applies oil paint in quick, short brush strokes, capturing the warmth and energy of the fields ready for harvest. Bright yellows, hot greens, pinks and oranges describe the gentle contours of the land and convey a feeling of openness and joy.

A group of children playing in the long shadows of the farmhouse in *Brittany, France* attests to Carr's habit of working into the late afternoon. Here, she simplifies form and uses dramatic colour, contrasting the warm yellow of the sun with the deep purple shadows.

Before Carr returned to Canada, two of her works were exhibited at the Salon d'Automne, the juried exhibition of New Art held in Paris each fall. Assured that her seeing had broadened and grateful for the artistic awakening she had experienced in France, she left for home, "still mystified...as to how to tackle our big West."

Emily Carr, *Brittany, France*, c. 1911; oil on millboard, 46.8 x 61.7 cm; McMichael Canadian Art Collection, Kleinburg. Gift of the Founders, Robert and Signe McMichael, 1974.

Emily Carr, *Autumn in France*, 1911; oil on cardboard, 49.0 x 65.9 cm; National Gallery of Canada, Ottawa.

Sketching Trips

KWAKIUTL HOUSE

After a brief stop in Victoria to visit her sisters, Emily Carr moved back once again to Vancouver, in 1912. There, she rented a studio and held an exhibition of the work she had produced in France. These paintings were among the most modern in Canada at that time, even more modern than the work of several Ontario artists who, in 1920, would form the Group of Seven and subsequently would inspire Carr.

The response to the painting she had done in France was mixed. Some critics, more sympathetic to modern art, praised her brilliant use of colour: "Miss Carr obtains some startling effects of light, and her technique is of great breadth and vigour." There were others, however, who expected art to mirror nature. They were unable to support the idea expressed in Carr's 1912 letter to *The Province*, in which she insisted that "a picture should be more than meets the eye of the ordinary observer....Art is art, nature is nature, you cannot improve upon it....Pictures should be inspired by nature, but made in the soul of the artist, it is the soul of the individual that counts."

In July of 1912, she bravely set out on one of her most ambitious excursions into northern British Columbia. Equipped with painting supplies, a portable easel, blankets and food to survive in what would be uncertain living conditions, Carr was accompanied by her constant companion, her sheepdog Billie. She travelled by any means available—on large steamers that sailed between the bigger coastal villages and in small motorboats or canoes that she hired privately.

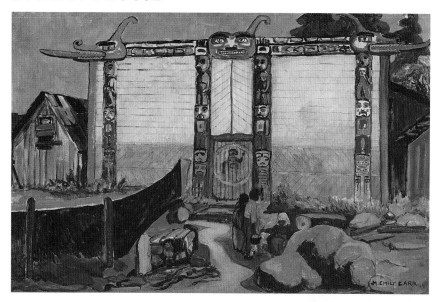

Her first stops were in the Kwakiutl villages on the east coast of Vancouver Island. In the village of Tsatsinuchomi, she painted inside a large community house, where the presence of the elaborately carved house post identified it as the former home of a high-ranking chief. In *House Post, Tsatsinuchomi, B.C.*, she uses a palette of primary colours—reds, blues and yellows—to illuminate the details of the spread-winged raven and to convey its powerful presence.

In *Kwakiutl House*, we are invited up the winding path, past a small group of people, to a large community house decorated with tall totem poles that tell of the ancestry of the people who had lived there. Heavy black lines describe the figures and animals, and the reds, yellows and oranges create a sense of warmth and intensity not seen in Carr's pre-France watercolours. "I could not go back to the old dead way of working after I have tasted the joys of the new," she wrote. "The new ideas are big and they fit this big land."

Emily Carr, *Kwakiutl House*, 1912; oil, canvas on composition board, 59.4 x 90.7 cm; VAG 42.3.33. Emily Carr Trust. Courtesy Vancouver Art Gallery. Photograph by Trevor Mills.

HOUSE POST, TSATSINUCHOMI, B.C.

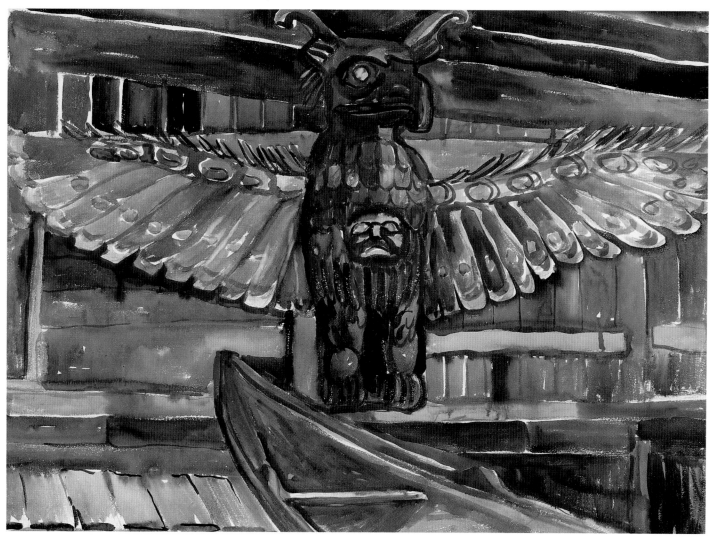

Emily Carr, *House Post, Tsatsinuchomi, B.C.,* c. 1912; watercolour over graphite on wove paper, 55.4 x 76.6 cm; National Gallery of Canada, Ottawa.

Making a Collection for History

During the summer of 1912, Emily Carr was able to visit more than 15 native villages along the B.C. coast. Some were deserted, while others were still inhabited. It was important that she sketch quickly when she stopped, as the boatman—who was paid by the hour—waited for her offshore. Working in pencil and in watercolour, Carr regarded these sketches both as finished works that recorded the details of the carvings and as models for future oil paintings that would better convey the individual spirit of a place.

As part of her journey, she travelled north to the Queen Charlotte Islands, the home of the Haida. By the time Carr visited this area, the Haida population had been drastically reduced by diseases introduced to North America by the Europeans in the 19th century, and many of the villages were abandoned.

In *Klee Wyck*, she characterized Skedans as "smothered now under a green tangle" with its "battered row of totem poles" circling the shallow bay. Her watercolour *Skedans in the Rain* was painted on site and mirrors her description. Here, the lushness of the green grass and hills contrasts with the pale grey of the poles, weathered and bleached by the wind and sun. Small raindrops have scattered across the paper and mixed with the paint, a reminder of the wet-weather conditions in which Carr frequently worked.

When she stopped at Guyasdoms, most of the people were away from the village, working in the canneries downstream. In *Old Indian House, Northern British Columbia*, we see figures laden with sacks of supplies climbing the steps to the painted house. These figures were probably added by Carr in her studio to give a sense of scale to the totem entrance and to create an impression of vitality in the village.

Carr's travels that summer touched her deeply, inspiring her to present a "Lecture on Totems," in which she declared publicly the perilous state of affairs as she saw them: "These poles are fast becoming extinct, every year sees some of their number fall, rotted with age; others bought and carried off to museums in various parts of the world." Not recognizing that First Nations culture had always been in evolution, even prior to the arrival of the Europeans, Carr feared for its future.

After two months of travel, Carr had produced close to 200 works. The challenge now was to find a home for her collection so that it might serve the purposes of history.

Emily Carr, *Skedans in the Rain*, 1912; watercolour. Courtesy British Columbia Archives and Records Service; Catalogue #PDP 2311.

Emily Carr, *Old Indian House, Northern British Columbia. Indians Returning From Canneries to Guyasdoms Village,* 1912; oil on canvas, 96.2 x 65.1 cm; VAG 42.3.51. Courtesy Vancouver Art Gallery. Photograph by Trevor Mills.

Rejected

When Emily Carr heard that the provincial government in Victoria planned to add a new wing to the Parliament Buildings, she urged government officials to purchase her collection for its library. Carr was seeking two things: she wanted the province to exhibit her paintings so that others could benefit from the art she had worked so hard to create, and she wanted the province's assistance in financing future trips to native sites.

Initially, the provincial government expressed interest in Carr's paintings and sought the opinion of Dr. C.F. Newcombe, an eminent ethnologist. Upon viewing her work, however, Newcombe found that Carr's artistic intentions were at odds with the government's requirements for a historical record. "The paintings were too brilliant and vivid to be true to the actual conditions of the coastal villages," he advised, and the paint was "laid on with a heavy hand."

In April of 1913, disappointed but not defeated, Carr held a large exhibition of works inspired by her travels to First Nations villages. From the early watercolours of Ucluelet in 1899 to the brightly hued oil paintings of her recent trips, the changes that visitors saw were remarkable. The new work not only was more boldly painted but tended to be larger, and paintings such as *Tanoo, Queen Charlotte Islands,* which is almost five feet wide, reflected her ambition to convey the powerful impact that these places had on her.

In the chapter on Tanoo in *Klee Wyck,* Carr described the "three fine house fronts" with delicately carved and painted poles at the entrances. We see them in the painting, faded by the wind

and the sun, stable and abiding against the moving grasses in the foreground. The soft pinks and greys of the wood contrast with the lively colours of nature, evoking Carr's response to the haunting stillness of Tanoo.

Reviews of the exhibition were once again mixed. While there was praise for works such as *Indian War Canoe, Alert Bay,* because they depicted rarely seen objects, it was the poor sales and the negative criticism that Carr remembered. In *Growing Pains,* she complained of the scorn and insults from people who expected a photographic representation of the totem poles. Carr continued to believe in the importance of expressing the spirit of the places she had visited.

Although her convictions were strong, her hopes of making a living as an artist in Vancouver were dashed. Without an income, she could no longer afford her studio, and she returned to Victoria with another scheme in mind.

Emily Carr, *Indian War Canoe, Alert Bay,* 1912; oil on cardboard. Collection of the Montreal Museum of Fine Arts.

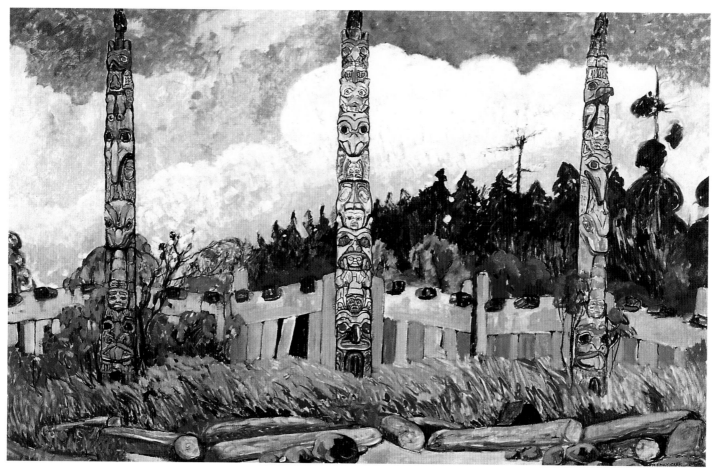

Emily Carr, *Tanoo, Queen Charlotte Islands*, 1913; oil on canvas. British Columbia Archives and Records Service; Catalogue #PDP 2145.

The House of All Sorts

Back in Victoria, Emily Carr built a house on land she had inherited from her father. The house was subdivided into four apartments, and her plan was to rent out three of them and keep the fourth for herself. She would continue to paint, supporting herself on the rental income. It seemed like a good idea at the time, but as Carr explained in *Growing Pains*, "no sooner was the house finished than the First World War came. Rentals sank, living rose. I could not afford help. I must be owner, agent, landlady and janitor. I loathed landladying."

Carr's memories of the hard work and the frustrations involved in running a boardinghouse furnished the stories for *The House of All Sorts*. Written many years later, the book chronicles her endless trials as a landlady. From problems with the architect—"a querulous, dictatorial man"—to the difficulties of dealing with an eccentric collection of tenants, the daily responsibilities overwhelmed her time and desire for art.

"Clay and Bobtails saved me," wrote Carr in *Growing Pains*, when she realized that in order to make ends meet, she would need more money than the rental income provided. Turning her land to profit, she raised and sold English bobtail sheepdogs, as well as fruit, hens and rabbits. She built a kiln and fired and sold her own pottery, and she maintained her long-standing interest in First Nations art by decorating the clay pots and hooked rugs with native designs.

Between 1913 and 1927, Carr produced approximately 20 paintings. They are small in size, reflecting both her diminished ambition and her reduced financial circumstances. Occasionally, she escaped with her paints and easel to nearby Beacon Hill Park, where the tall red-trunked arbutus trees, typical of British Columbia, were ready subjects for her art.

In *Arbutus Tree*, boldly applied mauve and orange oil paints define a tree trunk that stands out against the dense green foliage and blue sky. Despite the brightness of the colours, the composition seems rushed and slightly awkward —a sign that perhaps Carr was not in the habit of painting very often, burdened, as she now was, with the mundane and exhausting responsibilities of being a landlady.

Emily Carr with sheepdog, birds and cats, 1918. Photograph courtesy British Columbia Archives and Records Service; Catalogue #51747.

ARBUTUS TREE

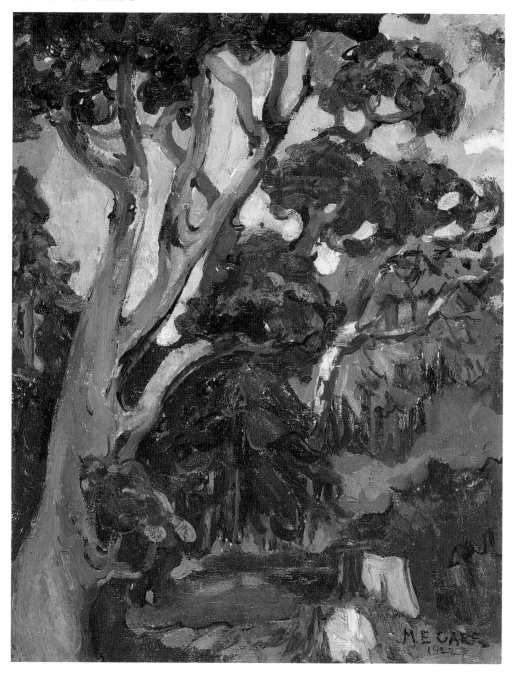

Emily Carr, *Arbutus Tree*, 1922; oil on canvas, 46.0 x 36.0 cm; National Gallery of Canada, Ottawa. Thomas Gardiner Keir Bequest, 1990.

The Turning Point

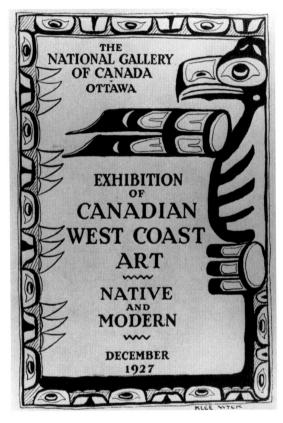

THE
NATIONAL GALLERY
OF CANADA
OTTAWA

EXHIBITION
OF
CANADIAN
WEST COAST
ART
~~~
NATIVE
AND
MODERN
~~~
DECEMBER
1927

KLEE WYCK

The artistically lean years of "The House of All Sorts" ended in 1927 when Eric Brown, director of the National Gallery of Canada, invited Emily Carr to participate in the "Exhibition of Canadian West Coast Art—Native and Modern" in Ottawa. The exhibition featured the work of First Nations artists as well as other artists who had visited and painted West Coast native sites. In the company of some of Canada's more "established" artists, such as A.Y. Jackson, Edwin Holgate and Lawren Harris, Carr showed the greatest number of works: 26 paintings, four hooked rugs and several pieces of decorated pottery. In the photograph at right, we see the "native and modern" works freely integrated in the galleries, among them, two of Carr's 1913 oil paintings and a hooked rug.

In her journals, later published as *Hundreds and Thousands*, Carr mentions that she was invited to design the cover for the exhibition catalogue. Combining a totemlike bird with a border of eyes, claws and teeth, she signed the piece as "Klee Wyck," the name given to her by the Nuu-Chah-Nulth of Ucluelet in 1899.

While Carr's inclusion in the exhibition was an exciting moment in her career, it was her meeting with the Toronto-based Group of Seven that would transform her life as an artist. In her journals, Carr writes with breathless excitement about her visits to the studios of the artists who were revolutionizing Canadian art and about the range of expression she saw in their work. A.Y. Jackson's paintings offered a "rhythm and poetry" that she felt her painting lacked, and in Arthur Lismer's work, she admired the "sweep and rhythm of the lines, stronger colours and simpler forms." But the artist who impressed her the most was Lawren Harris, whose work caused her to exclaim, "Oh, God, what have I seen, Where have I been? Something has spoken to the very soul of me, wonderful, mighty, not of this world."

In the Group of Seven's bold, colourful style and its passion for the Canadian landscape, she found an echo of her own efforts to express the spirit of the West Coast landscape and culture. Encouraged by the artists' acceptance of her work and especially by Harris's words—"You are one of us"—Carr returned to Victoria, resolved "to look for things I did not know of before, and...to feel and strive and earnestly try to be true and sincere to the country and myself."

Poster for the "Exhibition of Canadian West Coast Art—Native and Modern," December 1927, sponsored by the National Gallery of Canada, Ottawa. Cover designed by Emily Carr. Courtesy National Gallery of Canada, Ottawa.

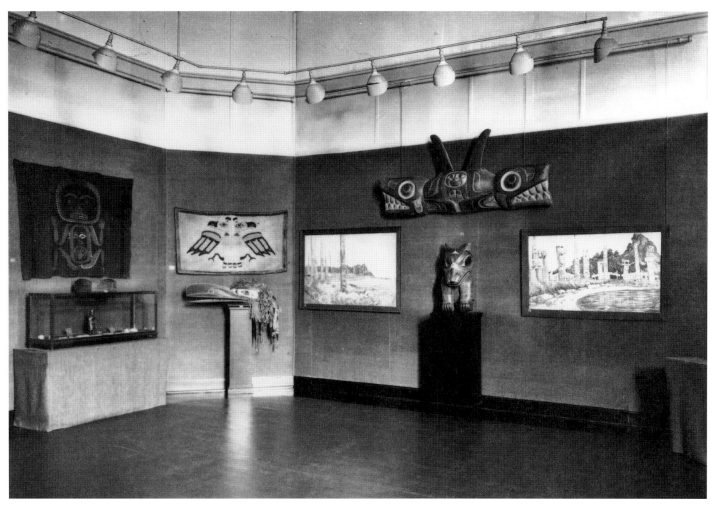

Installation photograph of 1927 "Exhibition of Canadian West Coast Art—Native and Modern," featuring three of Emily Carr's works. Courtesy National Gallery of Canada, Ottawa.

'God Bless the Group of Seven'

Emily Carr's excitement about painting was echoed in a burst of journal writing. Over the next 10 years, these journals would provide an almost steady record of her thoughts and feelings.

"When will I start to work?" was one of the first entries upon her return to Victoria. "Lawren Harris's pictures are still in my brain...they make my thoughts and life better....They are the biggest, strongest part of my whole trip East. It is as if a door had opened, a door into unknown tranquil spaces."

In recalling the effect of Harris's trees in *Above Lake Superior*, Carr wrote, "Bleached, wonderful, in purified abandon, they are marvellous." But what she most admired was the kind of spiritual world inspired by nature that Harris had produced: "...a world stripped bare of earthiness, shorn of fretting details...filled with wonderful serenity." In the stark, still landscape of *Above Lake Superior*, Carr saw how the smooth forms and clear light suggested another world, a spiritual place: "I think perhaps I shall find God here, the God I've longed for and failed to find."

In the winter of 1928, Carr was able to put aside the demands of her tenants and start to paint again, turning to her 1912 sketches of First Nations villages for inspiration. In an attempt to evoke the haunting spirit of the village in *Skidegate*, she explored Harris's language of simplified forms, defined by smooth applications of

paint. Starkly shaped houses and simplified trees are dominated by the looming presence of the totem pole, which lends an air of mystery to the peaceful village.

Why was Carr so taken with the spiritual nature of Harris's art? Despite her youthful rejection of organized religion, with which she had associated her sisters' charity work and the conventions of polite Victoria society, she was, nevertheless, religious. Through her earlier art, Carr had already begun to search for deeper meaning. Harris's approach—to transform nature in order to achieve spiritual expression—was therefore "an answer to a great longing."

Lawren Harris, *Above Lake Superior*, c. 1922; oil on canvas, 121.9 x 152.4 cm; Art Gallery of Ontario, Toronto. Gift from the Reuben and Kate Leonard Canadian Fund, 1929. Photograph by Larry Ostrom.

Emily Carr, *Skidegate*,
1928; oil on canvas,
61 x 45.5 cm; VAG 42.3.48.
Vancouver Art Gallery.
Photograph by Trevor Mills.

'Modern' Pictures

In the summer of 1928, Emily Carr embarked on one of her most strenuous journeys to the northern coastal villages of British Columbia, near the Skeena and Nass rivers. Her enthusiasm for First Nations art had been rejuvenated by the link she now saw between it and the spiritual vision of Lawren Harris. In fashioning legendary creatures and totem poles, native artists were reaching beyond earthly appearances, just as Harris, in transforming nature in his art, sought to evoke worlds beyond this one.

That autumn, a visit from an American artist from Seattle named Mark Tobey brought further changes to Carr's art. In a three-week studio course, Tobey introduced Carr to a kind of Cubism. Devised in the early 20th century by European artists Pablo Picasso and Georges Braque, Cubism was named for a style of painting in which the forms in nature are represented as little cubes. Through such simplification, the artists of Tobey's generation believed they were expressing inner states or realities.

On Tobey's recommendation, Carr purchased Harold Pearson's book *How to Look at Modern Pictures* and copied drawings from it to explore the ways the forms in nature could be reduced to geometric shapes. For Carr, these ideas complemented Harris's approach of streamlining nature's forms to achieve spiritual expression. Carr also saw a connection between First Nations art and the "modern" ideas. In a 1929 article, "Modern and Indian Art of the West Coast," she stressed the fact that native artists, like modern artists, simplified the shapes of nature in order to

reveal "the hidden thing which is felt rather than seen, the 'reality' which underlies everything."

In *Klee Wyck*, Carr describes the difficult journey into Kitwancool and her first view of the totem poles, "black and clear against the sky." *Kitwancool Totems*, based on watercolour studies from her summer trip, was completed after she had been instructed by Tobey, and it reveals what she learned from him. The forms of the totem poles, houses and land are now heavily shaded and more geometrically solid and sculptural. We feel the powerful presence of the figures through Carr's placement of them in the foreground, allowing their large, rounded mass to contrast with the angular shape of the houses and the flatness of the sky. Rather than focusing on the details of the carvings, she emphasizes their sculptural form and their setting, as the sombre colours and dying light suggest a feeling of haunting sadness.

Emily Carr, *Untitled*, graphite drawing, 1928. Courtesy British Columbia Archives and Records Service; Catalogue #PDP 5733.

KITWANCOOL TOTEMS

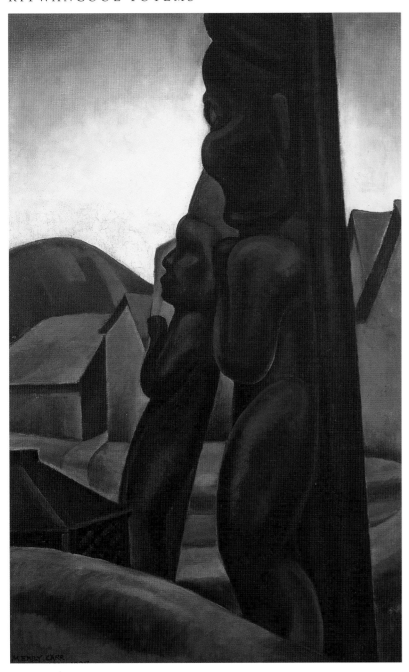

Emily Carr, *Kitwancool Totems*, 1928; oil on canvas. Hart House Permanent Collection, University of Toronto.

Correspondence With Harris

For many years after their initial meeting in 1927, Emily Carr and Lawren Harris maintained an intense correspondence. This exchange was particularly valuable to Carr, because it allowed her to clarify and explore new concepts in times of confusion and frustration.

Curious about the ideas behind Harris's work, Carr asked him to teach her more about his sources of inspiration. As a result, Harris introduced her to theosophy, a combination of world faiths that was at the heart of his system of beliefs. For the next six years, Carr did her best to absorb the books recommended by Harris. Although she found the exploration stimulating, she returned to Christianity—"I want the big God," she declared in her journals.

In 1929, Carr participated in the Ontario Society of Artists exhibition in Toronto, where she showed paintings inspired by her visits to Kitwancool and Skidegate. Harris was impressed by the great progress Carr had made in just two years. As a sign of his admiration, he bought *Indian Church*, perhaps seeing in the image of the simple white church centred in the dark, mysterious rainforest an embodiment of the balance and serenity he strove for in his own work.

The sketches for *Indian Church* depict the church at Friendly Cove on Vancouver Island's west coast, but in her painting, Carr has removed all of the particular details. As a result, the church becomes an image of *any* Christian church. Its simple geometric form, bright white like a symbol of truth and knowledge, contrasts boldly with the irregular organic shapes of nature. And although nature towers above the slim steeple and surrounds the humble graveyard, it does not overwhelm them, perhaps suggesting Carr's own desire to find harmony between her Christian beliefs and the power of nature.

Emily Carr, 1930, leaving for a sketching trip. Photograph by Nan Cheney. Nan Cheney Papers. Courtesy Special Collections Library, University of British Columbia, Vancouver.

INDIAN CHURCH

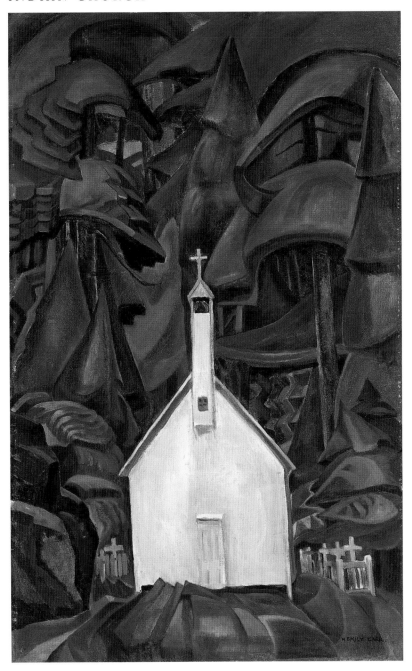

Emily Carr, *Indian Church*,
1929; oil on canvas,
108.6 x 68.9 cm;
Art Gallery of Ontario,
Toronto. Bequest of
Charles S. Band, 1970.
Photograph by
Carlo Catenazzi.

Fresh Seeing

ZUNOQUA OF THE CAT VILLAGE

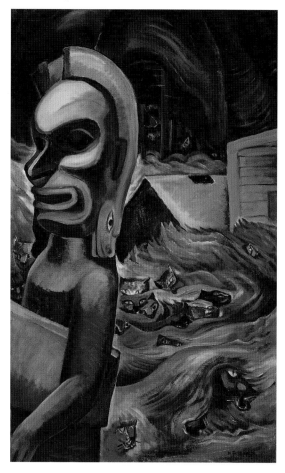

In 1930, Emily Carr accomplished more than most artists achieve in a decade. Her work was well received in Canadian exhibitions from Victoria to Toronto as well as in the U.S. cities of Seattle and Washington, D.C. After she sent five paintings to the Group of Seven exhibition in Toronto, she travelled East and was persuaded by Lawren Harris to continue on to New York. There, she enjoyed the modern masters of the early 20th century at the city's many art galleries.

Although she hated "like poison to talk," she gave two public lectures in that same year, which were later published in the book *Fresh Seeing*. In them, she presented her views on modern art, emphasizing the importance of distortion, which "raises the thing out of ordinary seeing into a more spiritual sphere."

By 1930, Carr was increasingly simplifying details and altering the shapes of nature. In *Vanquished*, she expresses her response to the deserted village of Skedans, convincing us of nature's energy as the large clawlike roots of fallen trees form a barrier on the beach and waves of irrepressible green foliage engulf the tall totem poles. Threatening clouds and the menacing shape of "Ghost Rock" in the background contribute to the mood of desolation and loneliness.

In August, Carr, now 59 years old, took what would be her last sketching trip to First Nations sites. Travelling around the northern tip of Vancouver Island, she stopped at several villages that had carvings of a legendary creature called Zunoqua. In one village, distinguished by its large community of cats, she came across a figure that she called Zunoqua, which was "graciously feminine...neither wooden nor stationary, but a singing spirit, young and fresh....Across her forehead her creator had fashioned the...mythical two-headed serpent."

In *Zunoqua of the Cat Village*, our attention is arrested by Carr's off-centre placement of a figure of Zunoqua, which seems to be almost striding out of the picture. Large and boldly carved, it towers above the sea of cats and the thick green undergrowth. Using a limited palette of browns and greens, Carr suggests the close integration of First Nations myth and nature—the "wild woman of the woods," in perfect harmony with the vitality of the forest.

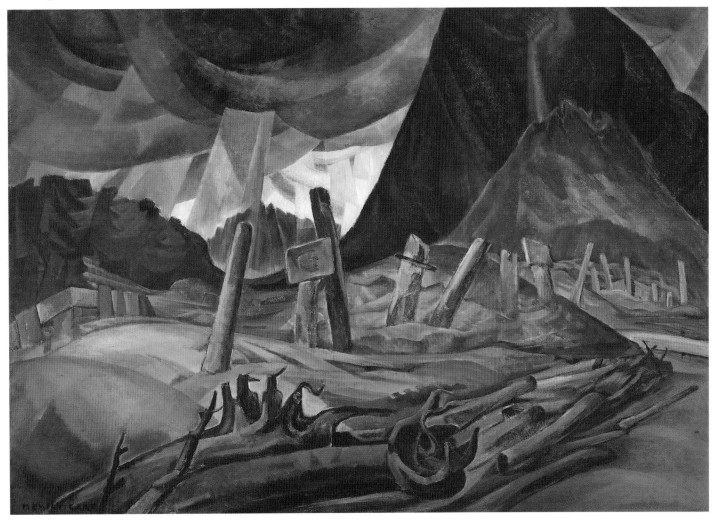

Emily Carr, *Vanquished*,
c. 1930; oil on canvas,
92.1 x 128.9 cm;
VAG 42.3.6. Courtesy
Vancouver Art Gallery.
Photograph by Trevor Mills.

Cumshewa

In exploring her "Indian" theme, Emily Carr often turned to earlier works that continued to have powerful meaning for her. A vivid recollection of her visit to Cumshewa, in the Queen Charlotte Islands, was embedded in her 1912 sketches—"they call to me and will not let me rest till I have brought them out and wrestled with them, dug into my memory and lived them over again."

"The memory of Cumshewa," she wrote in *Klee Wyck*, "is of a great lonesomeness smothered in a blur of rain." Her first response to Cumshewa, captured in the watercolour of the same name, uses lines that sway and curve gently, describing the single bird on its post and the rhythms of the land and sky. Billows of soft grey clouds capture the wet mistiness and contrast with the brighter colours of nature found in the blues of the hill and the red and green of the ground cover.

In her journals, Carr considered her ambitions for *Big Raven*: "I want to bring great loneliness to this canvas and a haunting broodiness, quiet and powerful." Although the composition for the oil painting is similar to the watercolour, the dark bird in *Big Raven* strongly dominates. Its smooth sculptural shape is echoed in the forms of nature that surround it, as if both are carved from the same substance.

CUMSHEWA

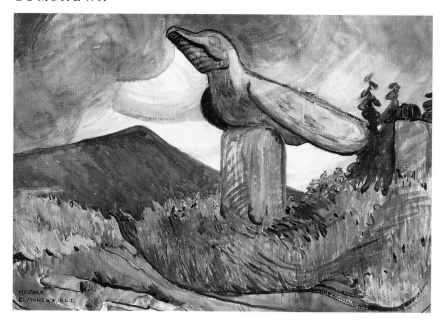

The arrangement of lights and darks in the two works is similar—with the white area of the sky throwing into profile the distant hill and the rounded form of the bird. But in the later work, the clouds are heavy and ominous and the shafts of light are like solid beams. In transforming nature and simplifying the carving, Carr hoped to express her response to its mysterious spirituality, standing "dilapidated and alone to watch dead Indian bones."

Summing up these changes in *Fresh Seeing*, Carr wrote: "Here I wanted something more—something deeper—not so concerned with what they looked like as what they felt like, and here I really was sweeping away the unnecessary and adding . . . something bigger."

Emily Carr, *Cumshewa*, c. 1912; watercolour over graphite on wove paper, mounted on cardboard, 52.0 x 75.5 cm; National Gallery of Canada, Ottawa.

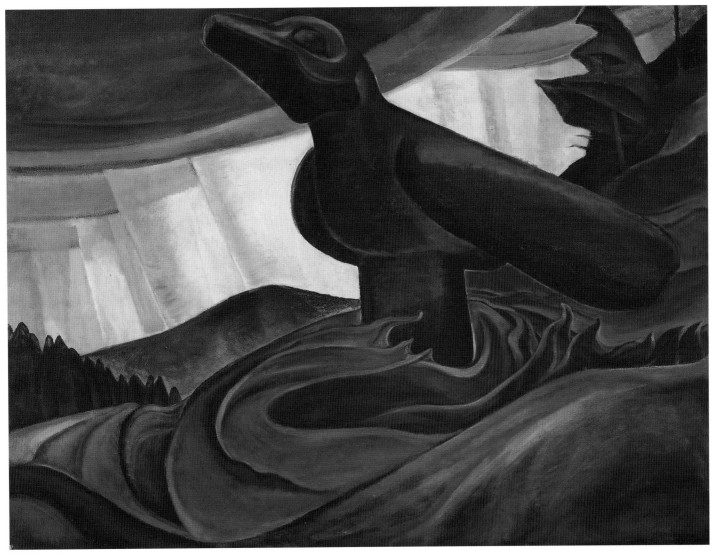

Emily Carr, *Big Raven*,
1931; oil on canvas,
87.3 x 114 cm;
VAG 42.3.11. Courtesy
Vancouver Art Gallery.
Photograph by Trevor Mills.

Charcoal Drawings

The process of drawing often gives an artist the freedom to experiment: The materials are not as costly as those for oil painting; the process is usually fast; and if the result is not satisfactory, neither much time nor money has been wasted. As a result, the artist is able to make advances and discoveries in drawing that can be explored later in other media.

In 1929 and 1930, Emily Carr created a number of large charcoal drawings in her studio. Unlike the rapid sketches she produced on the spot as studies for later paintings, these drawings are finished works in themselves and signal a gradual shift away from the First Nations carvings as her primary subject.

In the untitled drawing on this page, totemlike eye shapes merge with conical tree forms that look almost as if they, too, have been carved. It is not clear exactly what we are looking at—have the carvings merged with the forest, or has the forest merged with the carvings? Either way, Carr is expressing her strong beliefs about the relationship between First Nations art and the forest: They are not only linked but are made from the same materials, and both are rooted in nature. The eye of the totem has become the eye of the forest. Carr's ideas are further reinforced by the way she uses the charcoal, employing dark distinct lines to describe both the eyes and the trees and adding heavy shading to create a sense of sculptural form.

In the untitled drawing of a landscape at right, Carr's use of the charcoal is much softer. Delicate shades of black and grey create smooth tonal transitions which lead the eye beyond the forest

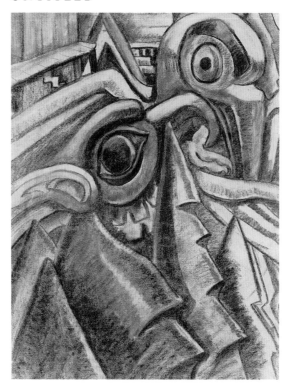

Emily Carr, *Untitled*, 1929-39; charcoal, 62.8 x 47.7 cm; VAG 42.2.123. Courtesy Vancouver Art Gallery.

to an opening in the sky that seems to look back at us. Here, the feeling of space is expansive, the mood peaceful and serene, as light and life radiate from the eye of the heavens or, for Carr, from the eye of God. The ideas manifest in the drawing are also echoed in her journals of the time: "Nature is God revealing himself, expressing his wonders and his love, Nature clothed in God's beauty of holiness."

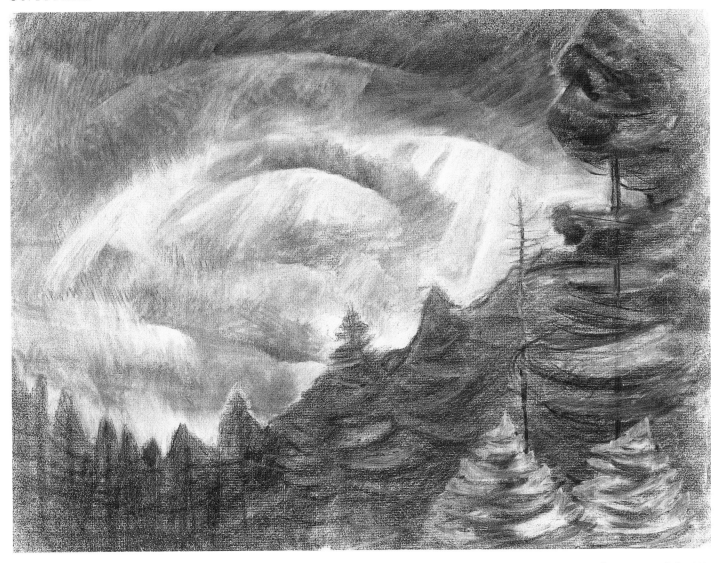

Emily Carr, *Untitled*, 1930;
charcoal; VAG 42.3.136.
Courtesy Vancouver
Art Gallery.

Indian Art and Nature Are One

TOTEM AND FOREST

The ideas that Emily Carr explored in her drawings soon began to drift into her paintings. Slowly, the forest began to replace the totem pole as the major subject of her work.

Lawren Harris had already encouraged her to make this transition late in 1929. Carr explained in *Growing Pains*: "Mr. Harris's advice was, 'For a while at least, give up the Indian motifs. Perhaps you have become too dependent on them; create forms for yourself, direct from nature.' " Carr, too, realized it was time to find a subject that was more her own: "While working on the Indian stuff I felt a little that I was but copying the Indian idiom instead of expressing my own findings."

In *Old Time Coast Village*, she has reduced the houses of the silent village to small white rectangles and the totem poles to narrow vertical shapes. The forest, solid, sculpted and heavy, now dominates our view. Like rows of dark-green-hooded priests solemnly gathered, the trees of the forest have acquired the rounded carved shapes once associated with Carr's depictions of the First Nations carvings.

Although the totem pole is central to the foreground of *Totem and Forest* and lends its shape to the canvas, its power to evoke the supernatural is now shared with the forest. The trees, sculpted with their own eyes, mouths and heads, flank the totem pole and hold it in a balance, suggesting the unity of First Nations art and nature.

In leaving the First Nations subject behind, Carr embraced the world of nature as the vehicle to evoke her spiritual beliefs as well as her feelings and moods. Soon, she would move away from the dark forests and discover other landscapes, which would in turn reveal happier sides of her character.

Emily Carr, *Totem and Forest*, 1931; oil on canvas, 128.8 x 55.9 cm; VAG 42.3.1. Courtesy Vancouver Art Gallery. Photograph by Trevor Mills.

Emily Carr, *Old Time Coast Village*, 1929-30; oil on canvas, 91.3 x 128.7 cm; VAG 42.3.4. Emily Carr Trust. Courtesy Vancouver Art Gallery. Photograph by Trevor Mills.

Oil on Paper

"I went no more then to the far villages," wrote Emily Carr in *Growing Pains*, "but to the deep quiet woods near home where I sat staring, staring, staring—half lost, learning a new language, or rather the same language in a different dialect."

Although Carr had decided to focus just on nature, the approach she took in paintings such as *Forest, British Columbia* was still rooted in the style she had used to paint totem poles. Carved shafts of light miraculously float between the trees that stand solid and immobile like the wings of a stage set.

Carr found that this view of nature—dark and forbidding—did not really reflect her stated purpose for art, which was "to rise above the external and the temporary…to express…the God, in all life, in all growth." In *Growing Pains*, she wrote of the need for greater freedom to express these ideas in her painting and realized that she must loosen up, "must use broad surfaces, not stint material or space." With this resolve, she invented a new technique for herself, which she described in a letter to Eric Brown at the National Gallery of Canada: "Oil paint thinned with gasoline on paper. It is inexpensive, light to carry, and allows great freedom of thought and action. Woods and skies out west are big. You can't pin them down."

Liberated by the fast-drying character of oil paint thinned with gasoline and by the large size of the cheap Manila paper, Carr could work quickly and spontaneously, joyfully expressing the liveliness of the forest. In *Tree (spiralling upward)*, nature is no longer static and sculptural but is a vital breathing entity. Movement now becomes a major theme of her work, one she often discussed in her journals: "A main movement must run through the picture….The movement shall be so great the picture will rock and sway together, carrying the artist and after him the looker with it." As the colours of the earth mix with the greens of the tree and spiral upward, we are lifted into the swirl of branches and become one with the vision and the feelings of the artist.

Emily Carr, *Forest, British Columbia*, c. 1931-32; oil on canvas, 130.0 x 86.8 cm; VAG 42.3.9. Emily Carr Trust. Courtesy Vancouver Art Gallery. Photograph by Trevor Mills.

TREE (SPIRALLING UPWARD)

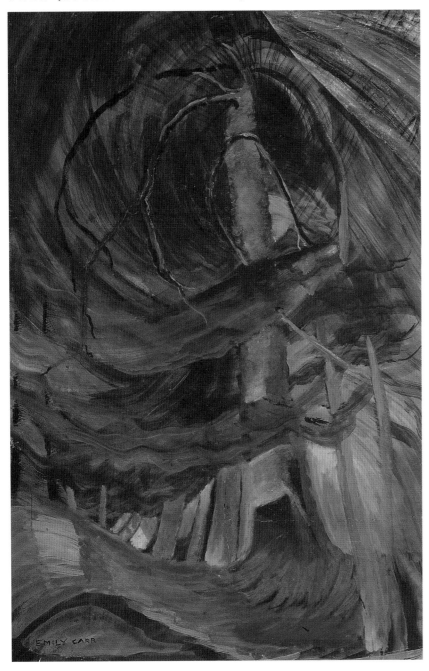

Emily Carr, *Tree (spiralling upward)*, 1932-33; oil on paper, 87.5 x 58.0 cm; VAG 42.3.63. Courtesy Vancouver Art Gallery. Photograph by Trevor Mills.

The Elephant

Emily Carr was a practical person who never let ordinary conventions stand in her way. To create more floor space in her studio, for example, she hoisted the unneeded chairs to the ceiling using ropes and pulleys. When setting out to collect clay for her pottery, she often used a baby carriage, because it was easy to push with a heavy load. When it came to art, the same instinct for finding original solutions prevailed.

In 1933, tired of the expense and inconvenience of renting small cottages from which to sketch during the summer months, Carr purchased a caravan, or trailer. Fitting up the interior for sleeping, cooking and working, she arranged to have it towed, over the next four summers, to a variety of sites not far from Victoria. Its arrival in her life is recorded in her journals: "Dreams do come true sometimes. Caravans ran around inside of my head from the time I was no-high.... Then one day, plop!... dropped the caravan. There it sat, grey and lumbering like an elephant."

The summer sketching trips with the Elephant, which she shared with her monkey, rat and four dogs, were among Carr's happiest, and her journals mirrored her feelings of fulfilment:

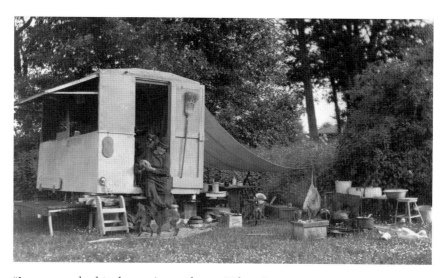

"I guess my bed is the van's very heart. When I am tucked up there, I am very content.... When I lie cosy and the wind is howling round outside...I can peep out the little window....And the sounds of the trees and the birds...seem so much apart that you can't quite make out if they are in your head or in the world."

Carr's sense of freedom, joy and delight in her search for harmony with nature is readily reflected in many of the oil-on-paper paintings done over those years. In *Abstract Tree Forms*, for example, trees and branches have been transformed into sweeping ribbons of colour dancing across the surface: "It is a swinging rhythm of thought, swaying back and forth...filling space, leaving space, shouting but silent."

Emily Carr, the Elephant and Friends, May 1934. British Columbia Archives and Records Service; Catalogue #94206.

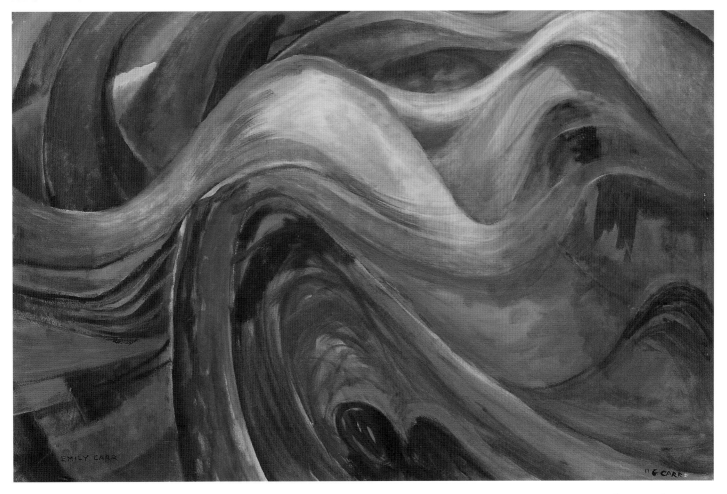

Emily Carr, *Abstract Tree
Forms*, c. 1932; oil on
paper, 61.0 x 93.5 cm;
VAG 42.3.54. Courtesy
Vancouver Art Gallery.
Photograph by Trevor Mills.

Scorned as Timber

Scorned as Timber, Beloved of the Sky is among the most famous of Emily Carr's paintings. A delicate pine tree rises tall and alone amid stumps and smaller trees and is the centre of a bright white light that seems to radiate from it. Rejected as lumber, the tree continues to grow, reaching toward the heavens like a symbol of hope.

In her writings, Carr often expressed dismay over the cutting of trees, whether it was to make room for the expansion of the city or to clear a forest for timber. Carr's deep emotional attachment to nature and her profound sense of identification with the trees themselves are echoed in her journals, in which she referred to tree stumps as "screamers": "These are the unsawn last bits, the cry of the tree's heart, wrenching and tearing apart just before she gives that sway and the dreadful groan of falling…while her executioners step back with their saws and axes. … It's a horrible sight."

It is also possible to look at this painting as a portrait of Carr herself. Not unlike "a lone old tree with no others round to strengthen it," she made her way as an artist, struggling against adverse criticism and forging on alone with no one but Lawren Harris in the East to encourage her in her new endeavours. In her journals, she fre-quently laments her solitude, the lack of companionship in her life and the isolation she felt at being cut off from the main centres of art in Canada.

Sometimes, Carr blamed herself for her solitude. She was fully aware of her crusty personality, her curt intolerance of people she regarded as insincere and her dogged determination to have things her way in order to grow as an artist: "It must be my fault…this repelling of mankind and at the same time rebelling at having no one to shake hands with but myself."

By 1935, when she painted *Scorned as Timber, Beloved of the Sky*, however, Carr had come to be appreciated as one of Canada's significant artists. Despite the poor sales of her work, she was finally able to take pride in her achievements, a pride perhaps expressed in the light shining from the tree. And Carr, like the lone tree, was a survivor, having achieved at last her purpose in art and life—to express "a climbing and a striving for something always beyond."

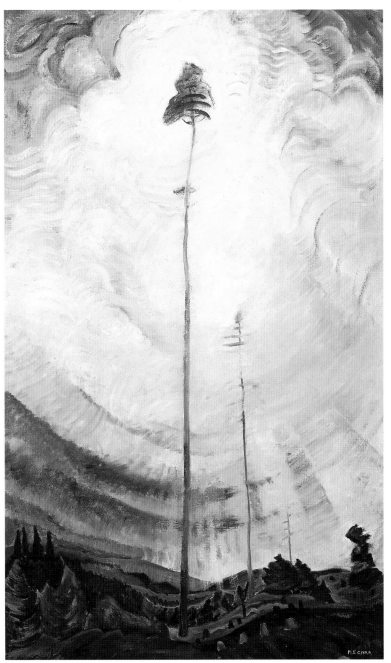

Emily Carr, *Scorned as Timber, Beloved of the Sky*, 1935; oil on canvas, 112.0 x 68.9 cm; VAG 42.3.15. Emily Carr Trust. Courtesy Vancouver Art Gallery. Photograph by Trevor Mills.

Skyscapes

In the summers of 1934 through 1936, Emily Carr had her caravan towed to Esquimalt Lagoon, in Metchosin, an area about 18 miles west of Victoria. At first, the Elephant was parked on a beach, but later, Carr had it moved to higher ground, where she had a splendid view of the sea and the open skies. Carr had considered this change in subject a few years earlier, asking: "Why don't I have a try at painting the rocks and cliffs and sea? Wouldn't it be good to rest the woods? Am I one-idea'd, small, narrow? God is in them all."

Although she was unsure about sketching away from the familiar shelter of the forest, Carr's enthusiastic response to the wide-open spaces of the seaside is reflected in her paintings. Once again, the oil paint mixed with gasoline proved to be the best medium. Fast-drying and fluid, it allowed her to make large, sweeping gestures with her brush, to respond quickly and freely to the vibrant light and the feeling of infinite space.

The easy portability and light weight of the materials for the oil-on-paper paintings were attractive to Carr, but her particular choice of paper was unfortunate. Money was always a problem, and Carr skimped on materials as much as she could, buying only the most inexpensive papers. Over time, the papers have darkened, lending warm yellow or orange background tones to the images, which the artist may never have intended.

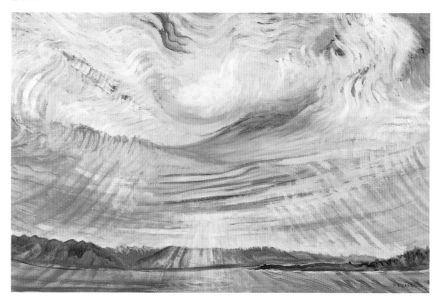

In paintings such as *Sky*, the heavens breathe with life as quivering brush strokes carry the eye upward to a swirl of clouds, where light and life radiate beyond the frame like unbounded gladness. "A main movement must run through the picture," she wrote in her journals. "The transitions must be easy [and] shall express some attribute of God—power, peace, strength, serenity, joy."

Graceful brush strokes define the contours of the rocks and hills in *Strait of Juan de Fuca* before sweeping up to the sky and then back down to the water in a continuous, almost fleeting, gesture of her arm. In her journals, Carr mused: "It seems as if those shimmering seas can scarcely bear a hand's touch. That which moves across the water is scarcely a happening. . . . It's more like a breath, involuntary and alive, coming, going, always there but impossible to hang on to. . . . Only spirit can touch this."

Emily Carr, *Sky*, c. 1935; oil on wove paper, 58.7 x 90.7 cm; National Gallery of Canada, Ottawa.

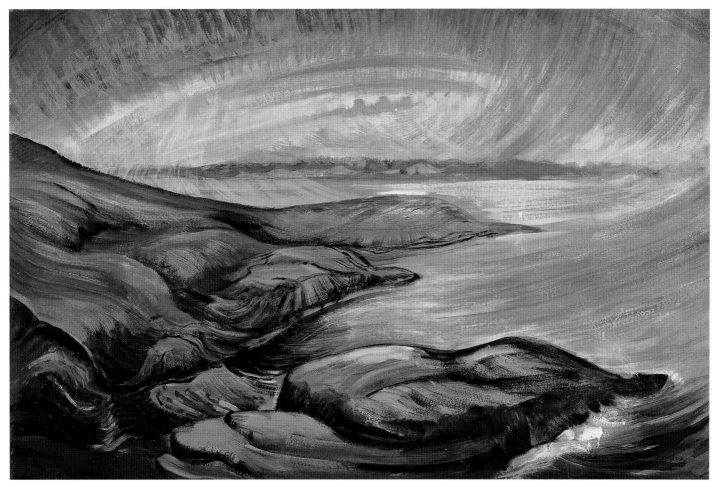

Emily Carr, *Strait of Juan de Fuca*, c. 1936; oil on paper, 60.7 x 91.3 cm; McMichael Canadian Art Collection, Kleinburg. Gift of Dr. and Mrs. Max Stern, 1974.

Reforestation

"I am trying my best to get rid of the house," wrote Emily Carr to a friend in the fall of 1935. "It is just killing, rents so low & so hard to get tenants at all....I have not a bean."

By early 1936, Carr had sold "The House of All Sorts." Buying another house that she was able to rent out for $50 a month, she took a small cottage for herself at a cost of $25 a month. Despite poor health and an uncertain financial situation, Carr embraced her new neighbourhood, taking special pleasure in the children nearby: "Phyllis next door is a joy....She's an enormous waggle-tongue, chattering all day long, happy chatter... rushing pell mell in and out of the kitchen door."

That same delight in life fills paintings such as *Reforestation*, in which the lush green of generations of trees points upward to a swirling sky. Through a waving sea of undergrowth, our eyes travel past fragile baby saplings to mid-sized trees basking in the sunlight and then to the seniors, the dark green mature trees, the desired target of the logger's saw.

"What do these forests make you feel?" Carr asked in an unpublished journal. "They are profoundly solemn yet upliftingly joyous...they are growing and expanding, developing with the universe...springing from tiny seeds, pushing above mother Earth, fluffy baby things, first sheltering beneath their parents."

In Carr's writings, nature is often personified— the trees, for instance, are discussed as if they were members of a family. This was as much an expression of the deep bond the artist felt with nature as it was a reflection of the connections she saw between everything in life, all parts of the process of birth, growth and death.

In *Reforestation*, nature throbs with life and movement, as its never-ending and ever-healing growth "has repaired all the damage and hidden the scars." Carr had an optimistic view of nature's cycles that allowed her to see a purpose even in death and destruction. "Everything has to teach something else growth and development. Even the hideous wars are part of the growth and development," she wrote. "It may be that the great and strong are killed to give the shrivelled weaklings a chance."

Emily Carr with unidentified girl, December 1936. Photograph courtesy British Columbia Archives and Records Service; Catalogue #46029.

REFORESTATION

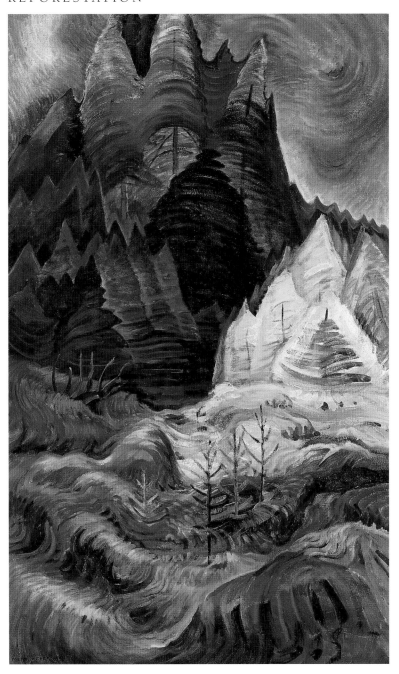

Emily Carr, *Reforestation*,
1936; oil on canvas,
110.0 x 67.2 cm;
McMichael Canadian
Art Collection, Kleinburg.
Gift of the Founders,
Robert and Signe
McMichael, 1966.

Writing

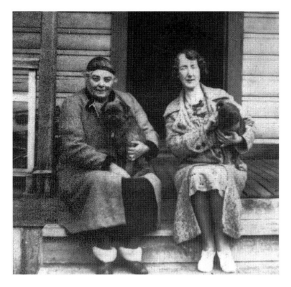

Emily Carr's interest in writing began in childhood, when she transformed the feelings of everyday life into poetry. As an art student in California and England, she delighted her friends with comical skits about her new experiences, illustrating them with drawings. And, during the 1920s, when she was running her boardinghouse, she began to compile stories that would be published in the 1940s.

It was later in life, however, that her writing took on the more serious proportions of her painting. Her meeting in 1927 with the members of the Group of Seven inspired not only a return to painting but a surge in writing in the journals that were later published under the title *Hundreds and Thousands*. "It seems to me it helps to write things and thoughts down," observed Carr. "It sorts out jumbled up thoughts and helps clarify them, and I want my thoughts clear for my work."

Early in 1937, Carr suffered a severe heart attack. Her doctors ordered strict rest from all strenuous activity, including outdoor sketching. Frustrated by the confinement, she quickly substituted writing for painting as an outlet for her feelings. As she explained in *Growing Pains*, "One approach is cut off, I'll try the other. I'll 'word' these things which during my life have touched me deeply." But in her journals, her reaction was more emotional: "While my heart sits pumping furious rebellion, my soul can glide out of itself and be among the trees.... It can smell the damp earth. Oh the joy of a travelling soul that has learned its way about the woods!"

Just as Carr had benefited from the counsel of Lawren Harris and Mark Tobey in painting, so in writing, she had her "listening ladies." Flora Burns and Ruth Humphrey, who was also a professor of English, each read her stories and offered constructive criticism. While Carr appreciated their encouragement, she also had advice for herself: "I did not know book rules. I made two for myself. They were about the same as the principles that I used in painting—get to the point as directly as you can; never use a big word if a little one will do."

Finally, a year and a half after her heart attack, Carr was able to sketch outside once again. The great joy that she felt at being back in the woods is reflected in *Sombreness Sunlit*, where radiant sunlight shoots between the trees, cutting through the solid trunks with speed and energy. Unlike the earlier composition of trees in Stanley Park, here the subject is light itself, a symbol of the hope and striving that always surfaced for Carr even in the darkest times.

Emily Carr with Flora Burns at Langford, British Columbia. Photograph courtesy British Columbia Archives and Records Service; Catalogue #51765.

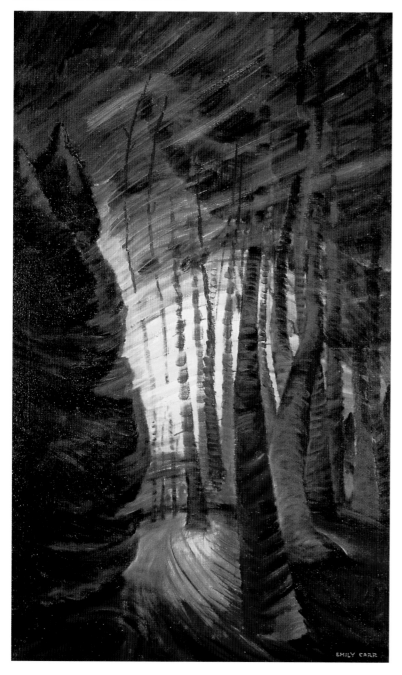

Emily Carr, *Sombreness Sunlit*, 1938-40; oil on canvas, 111.9 x 68.6 cm; Courtesy British Columbia Archives and Records Service; Catalogue #PDP 633.

Happiness

HAPPINESS

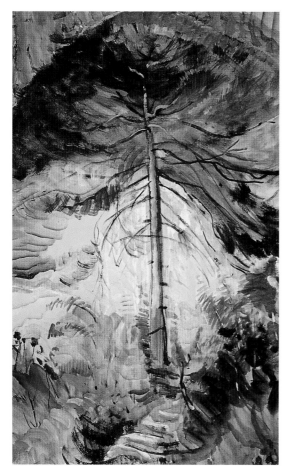

In 1939, as the Western world prepared for the Second World War, Emily Carr suffered another serious heart attack. While recovering in hospital, she devoted what energy she had to writing. By summer, she had received permission to start sketching out of doors and excitedly made plans to rent a cottage at Langford, west of Victoria. The cottage was nicknamed "Rat Hall," and Carr cheerfully described it in a letter to a friend: "Lovely out here and the habitation completely successful, weather less so…and appetite unfortunately (for the waist line) large.…We don't leak except chimneys. A family of young rats lives in the field under my window, pretty ones who live on the hay."

Although she complained in her journals about the hideousness of the war—"nations are hating and hissing, striking and wrecking and maiming"—her paintings during this year reflect the peace of her immediate surroundings and the inner harmony of her soul. In *Happiness*, a young tree, calmly centred on the page, spreads its branches like open arms to greet the viewer. Gentle rhythms created by the lines and shape of the tree are echoed in the rippling forest floor. Even the warm glow of the now yellowed paper seems to add to a feeling of delight. It is Carr's own happy spirit expressed through nature: "When I went into the woods I could rise and skip with the spring and forget my bad heart. Doesn't it show that the good and beautiful and lovely and inspiring will of nature is stronger than evil and cruelty? Life is bigger than war."

Carr's enduring spiritual quest continued to find new forms of expression in her painting. Beyond the image of the striving and hope that *Scorned as Timber, Beloved of the Sky* offers, *Above the Trees* invites us to float upward to the infinite blue heavens. As the rounded shapes of the tree-tops are echoed in the vibrating rhythms of the sky, life and energy are no longer earthbound but become one with the universe: "Oh, that dome! The blue is so much more than blue, the illusive depth boring into Heaven's floor."

Emily Carr, *Happiness*, 1939. Courtesy Maltwood Art Museum and Gallery, University of Victoria Collection; U990.17.1.

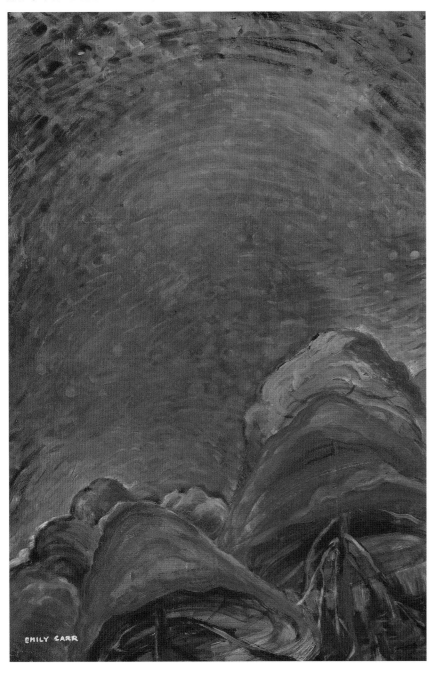

Emily Carr, *Above the Trees*,
c. 1939; VAG 42.3.83.
Courtesy Vancouver
Art Gallery. Photograph
by Jim Gorman.

New Growth

"New Growth" is the title given to the last slim section of Emily Carr's journals. For Carr, much of 1940 and 1941 was marked by frequent pain and regular stays in hospital, but there were still new branches on the old tree, as fresh form emerged in both Carr's writing and painting. In 1940, Carr moved in with her sister Alice, something of a return to roots, since Alice's house was built on the land where the family vegetable garden had once thrived.

Late in 1938, Carr's friend Ruth Humphrey showed Carr's stories to Ira Dilworth, a professor of English and a regional director for the Canadian Broadcasting Corporation. Dilworth arranged for the stories to be read on local and national radio and, following their very positive reception across the country, persuaded a Toronto publisher to print *Klee Wyck*.

Although Carr was shy about her lack of formal schooling as a writer and hesitant about accepting Dilworth's offer to help her with her texts, the editing of *Klee Wyck* galvanized their friendship, as each discovered a soul mate in the other. Carr described the experience in *Growing Pains*: "I shall never forget the editing of *Klee Wyck*—the joy of those hours—nor all it taught me. I was almost sorry to see her finished and shipped off to the publisher."

"*Klee Wyck* got wonderful press reviews," she wrote. "Letters, phone calls came from everywhere. People were not only warm but enthusiastic. I was staggered." In 1941, shortly before her seventieth birthday, Carr was presented with the Governor General's Award for literature. After years of being mistrustful of praise and recognition, she at last decided to take pride in her accomplishments and to enjoy it all. At her birthday party, Carr sat surrounded by hundreds of flowers and congratulatory letters from across Canada. "It was like having a beautiful funeral only being very much alive to enjoy it," she remembered in *Growing Pains*.

Despite her frail condition, Carr still found energy for painting, and the happiness and excitement of the experiences that initially inspired the 1912 paintings are recaptured in *A Skidegate Pole*. In contrast to the narrow format and the thick textural application of paint in the earlier works, here Carr uses an almost square format, creating a sense of balance between the carving and the landscape. Nature is full of light and movement, as the undulating greenness of the land is echoed in the feathered softness of the sky. The Haida shark pole, centred in the canvas, is integrated with nature, its soft green and brown tones mirroring the colours of the land and establishing a joyful sense of the unity in all creation.

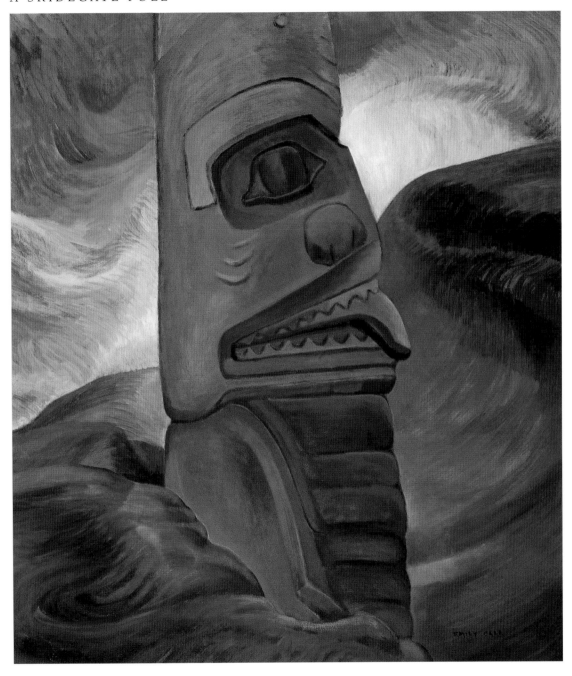

Emily Carr, *A Skidegate Pole*, c. 1942; oil on canvas, 86.4 x 76.2 cm; VAG 42.3.37. Courtesy Vancouver Art Gallery. Photograph by Trevor Mills.

Quiet

"Spring was young, I over seventy. With Spring all about me I sat sketching in the clearing.... Seventy years had maimed me, loggers had maimed the clearing…but I got immense delight in just being there, in the quiet wood," wrote Emily Carr in the last chapter of *Growing Pains*. This final sketching excursion—taken in August 1942—was against her doctor's advice, but for Carr, "the longing was too terrific to subdue, and I felt better."

Her deep contentment is readily reflected in *Cedar*, where dark green branches "fairy as ferns…heavy as heartaches" float delicately across the flat surface of the canvas. We are there with Carr, pressing our noses against their dancing boughs, inhaling their sweet, verdant freshness and feeling the great peacefulness of the forest. Undaunted by failing health, Carr once again finds new means to express her profound passion for nature.

The last three years of Carr's life were full of activity, despite the fact that she spent much of the time in pain, confined to bed or a wheelchair as the result of numerous strokes. In 1942, *The Book of Small* was published; in 1943, she was honoured by solo exhibitions in Montreal and Vancouver; and in 1944, as the war continued to rage, she published her third book, *The House of All Sorts*.

In February 1945, Carr threw herself into the preparations for an exhibition to be held at the Vancouver Art Gallery that spring. By the end of February, however, she was totally exhausted and entered a nursing home, where she fully intended to keep working. Recognizing her great physical weakness and perhaps anticipating her end, she wrote to Ira Dilworth: "I'm way off down a corridor where nobody ever comes and nothing ever happens." Three days later, on the second of March, she died.

Within months of Carr's death, the National Gallery of Canada and the Art Gallery of Toronto organized a large retrospective exhibition of her work, inviting her close friends Lawren Harris and Ira Dilworth to write the catalogue essays. Dilworth's words ring true today: "It is impossible to think of her work as finished—it goes on. It is equally impossible to estimate the influence it will exert."

Certainly, the countless artists, musicians, writers and dancers who were, and continue to be, inspired by Carr's art and writing are a testimony to the power of her work. Beyond the enduring appeal of her subjects—the art and culture of Canada's First Nations and the beauty of the West Coast landscape—it is Carr's soul, her vibrancy, courage and determination, that is at the heart of her influence.

Like the beautiful crocus that pushes through last autumn's leaves and winter's snow, the exuberant creativity and inner spirit of Emily Carr pushed forward, never deterred by the many hardships and obstacles that she encountered. The last words are Carr's: "Some can be active to a great age but enjoy little. I have lived."

CEDAR

Emily Carr, *Cedar*, 1942; oil on canvas, 112.0 x 69.0 cm; VAG 42.3.28. Emily Carr Trust. Courtesy Vancouver Art Gallery. Photograph by Trevor Mills.

Selected Sources

The list below offers a few sources for more detailed information about Emily Carr and her work. It also includes a list of Carr's published writings, from which the quotes in this book were taken. —A.N.

CARR'S WRITINGS

The Book of Small. 2nd ed. Toronto: Clarke, Irwin, 1972.

Fresh Seeing: Two Addresses by Emily Carr. Toronto: Clarke, Irwin, 1972.

Growing Pains. 1st paperback ed. Toronto: Clarke, Irwin, 1966.

The Heart of a Peacock. Toronto: Oxford University Press, 1953.

The House of All Sorts. Centennial ed. Toronto: Clarke, Irwin, 1971.

Hundreds and Thousands: The Journals of Emily Carr. Toronto: Clarke, Irwin, 1966.

Klee Wyck. Centennial ed. Toronto: Clarke, Irwin, 1966.

"Modern and Indian Art of the West Coast." *Supplement to the McGill News* (June 1929): pages 18-22.

Pause: A Sketch Book. Toronto: Clarke, Irwin, 1953.

BOOKS ABOUT CARR

Blanchard, Paula. *The Life of Emily Carr.* Vancouver: Douglas & McIntyre, 1987.

Hembroff-Schleicher, Edythe. *Emily Carr: The Untold Story.* Saanichton, British Columbia: Hancock House, 1978.

Shadbolt, Doris. *The Art of Emily Carr.* Vancouver: Douglas & McIntyre, 1979.

————. *Emily Carr.* Vancouver: Douglas & McIntyre, 1979.

Tippett, Maria. *Emily Carr: A Biography.* 1st paperback ed. Toronto: Stoddart Publishing Co. Limited, 1994.

Emily Carr—Her Paintings and Her Sketches. Toronto: Oxford University Press, 1945.